# DAVID BAILEY

Jackie Higgins

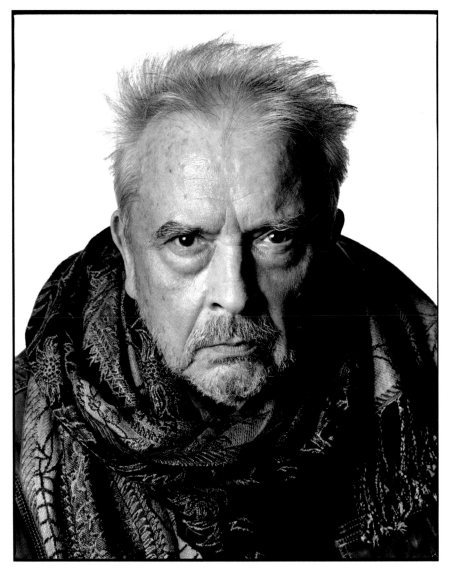

2.3

David Bailey has long been one of the most celebrated photographers in the world and his controversial reputation often precedes him. Indeed, one wonders where the myth stops and the man begins. Yet David Bailey's work should not be identified solely with the 1960s, nor be defined by his lifestyle. Over the past five decades, he has been a filmmaker, curator, magazine owner, environmental campaigner, painter and sculptor, as well as a photographer. His photography spans genres — from fashion to portraiture, nudes and erotica to documentary and reportage — yet common themes emerge. These photographs speak for themselves.

It is rewarding to re-examine Bailey's work from the 1960s and be reminded of the revolution it wrought on the fashion industry, as these formative years colour much of his subsequent output. Photography is rarely more elaborately staged and meticulously choreographed than in fashion. However, if Bailey's contribution to fashion photography can be summed up, it could be said that he injected ersatz realism to better this illusion. Perhaps it started on that now-legendary trip to New York for the British *Vogue* feature 'Young Idea Goes West' in January 1962, just six months into his relationship with model Jean Shrimpton. The shoestring budget only allowed for a three-person crew — Bailey, Shrimpton and their editor. There was neither hairdresser nor make-up artist for Shrimpton and, crucially, there was no camera assistant for Bailey, meaning he had to load film himself. 'Not only did I have no assistant,' Bailey recalled, '[but] it was so cold that the cameras stuck to your fingers.' So, rather than take a cumbersome medium-format camera and tripod, he opted for a hand-held 35mm single-lens reflex camera. This allowed him to shoot in a rapid, informal way, creating images in line with the cinema *vérité* style seen in *Nouvelle Vague*

films such as Jean-Luc Godard's *À bout de souffle* (1960), where hand-held cameras were used to evoke a sense of dynamism and realism. As Marit Allen, the precocious *Vogue* editor responsible for 'Young Idea', observed, 'Jean and Bailey in New York broke the ground for fashion as it was from then on. They turned the world upside down. Fashion was no longer static and stiff.'

New York was just the beginning; back home in his London studio, Bailey's quest to 'loosen up' the stilted, unnatural fashion image continued. Robin Muir, former picture editor of British *Vogue*, recounts how, before Bailey's arrival at the fashion magazine, one photographer had asked his model to pose as if to 'catch a butterfly'. Moreover, 'The ladies of *Vogue*, as portrayed contemporaneously by Henry Clarke, Claude Virgin and Eugene Vernier [did] nothing more effortful than sit and stare, hand on chin. Only occasionally ... do they break into anything quicker than a fast trot towards Claridge's.' By contrast, Bailey lifted gestures from street scenes and everyday life to create a new lexicon of naturalistic poses. He experimented with tight crops to imply action beyond the confines of the frame. The resulting studio compositions, as illustrated by *Jean Shrimpton* (page 17), exude the kind of dynamism and vitality he had just captured with his hand-held camera on the streets of Manhattan. These traits have come to be recognized today as part of the quintessential 'Bailey' style, from his fashion to portrait photography. The pose seen in *Jacques-Henri Lartigue* (page 53) is carefully choreographed yet betrays a spontaneity and lightness of touch. The framing of *Bruce Weber* (page 105), with its skewed skyline and off-kilter subject, creates a snapshot aesthetic reminiscent of the groundbreaking New York shoot. However, Martin Harrison, art historian and author of several books on the photographer, suggests Bailey's next move was

motivated by a complete disenchantment with artificiality, which 'bore fruit in the ruthless honesty of his *Box of Pin-Ups*'.

*David Bailey's Box of Pin-Ups* (1965) embraced a style of portraiture that was radically different from his fashion imagery. Of the thirty-seven *Box* portraits, showing actors, models, producers and other privileged members of the newly anointed 'Popocracy', thirty were taken against a plain white background. It was a technique that had been used by the director Richard Lester in The Beatles' film debut, *A Hard Day's Night* (1964). His cinematographer, Gilbert Taylor, explains: 'By using absolutely white backings and a key light, we could make the people who played against this "white-out" environment take on the definition of steel engravings.' Bailey pushed this style even further by combining the backdrop and stark lighting with high-contrast printing. In his portrait *John Lennon and Paul McCartney* (page 23), the two Beatles appear even more hard-edged than in Lester's film. In addition, the white background empties the photograph of context, aggressively isolating its subjects in a visual void. This encourages another interpretation, as art historian David Mellor explains, 'Figuratively speaking, those people in the *Box* (with exceptions like Lord Snowdon) – pop singers, art directors and photographers – were persons without backgrounds.' Or, in the words of writer and columnist Peter York, they 'stood out against the backdrop of Britain's tradition'. Lennon and McCartney, the two lads from Liverpool, like nearly all their *Box* counterparts, were new-comers from no remarkable social background. The absence of context serves the imagery of the *Box* stylistically and metaphorically. Bailey still uses this device, as can be seen in his portrait of *John Galliano* (page 113). It has become his signature style, yet there are elements that echo the photographic approach

of American photographer Richard Avedon, who was, even by the early 1960s, already a legend.

In the same year that Bailey started work on the *Box*, Avedon released his second, and arguably, most accomplished book, *Nothing Personal* (1964). On a superficial level, the two works have much in common. Avedon's monochrome images isolate their subjects against a white background; often only their heads and shoulders are depicted. Avedon said, 'You can't get at the thing itself, the real nature of the sitter, by stripping away the surface. The surface is all you've got.' By manipulating gesture, costume and expression, Avedon aimed to access his subject's psyche; his seemingly simplistic, straightforward style suggests that this psychological insight is authentic. Similarly, Bailey referred to his *Box* photographs as 'styleless' – the antithesis of fashion photography – suggesting clarity, objectivity and reality.

However, a deeper analysis reveals fundamental differences between *Nothing Personal* and *Box of Pin-Ups*. Avedon exploited lighting and printing to emphasize decay: the finely lined and liver-spotted face of Dwight Eisenhower reveals the ex-president's age and frailty. Avedon highlighted imperfect features in order to mock: Eisenhower's bald head and slight squint make him look almost infantile. The photographer selected poses to counter our expectations. In *Monroe*, the starlet Marilyn Monroe seems far from glamorous; with downcast eyes and slumped shoulders, she appears world-weary. Furthermore, Avedon used *Nothing Personal* to juxtapose portraits of celebrities with photographs of patients from a mental asylum – faces contorted in wild, desperate grimaces – clearly asking the reader to draw comparisons between the two groups. *Nothing Personal* demonstrates that Avedon is in the business of exposing the

myth of celebrity. By contrast, Bailey's *Box* honours and idolizes its subjects. Photographers are paired with ballet dancers, models with record producers; glamour spreads as stars rub shoulders. Here, lighting and printing are used to flatter – in *Mick Jagger* (page 21), the pop star's skin looks lustrous. Poses are used to deify – in *Jean Shrimpton* (page 31), the model is cast as goddess. Even the actual photographs appear luxurious: they were printed as high-quality, hand-fed gravure sheets. In this respect, Bailey was the antithesis of Avedon. Indeed, his style seems more in line with the work of another artist who, at the time, was on the verge of superstardom.

In the summer of 1963, Bailey returned to New York. He had been working for the *Vogue* junior magazine, *Glamour*, and its art director, Miki Denhof, who introduced Bailey to the up-and-coming artist, Andy Warhol. Bailey, and his companion Mick Jagger, made an impression on Warhol, who said of their meeting, 'They each had a distinctive way of dressing; Bailey all in black, and Mick in light-coloured, unlined suits with very tight hip trousers … And of course Bailey and Mick were both wearing shoes by Anello & Davide, the dance shoemaker in London.' However, Warhol arguably made a bigger impression on Bailey: 'I liked the idea that Andy was interested in objects that had been considered banal and turned them into art.' In the decade that commodified personality and moulded our conception of celebrity culture, Warhol recognized the power of the image, but also its emptiness. As photographer and art historian Max Kozloff observes, 'It was as if Warhol had served up a mess of tinsel – the myths of our consumerism – on a golden platter. There was no suffering behind the masks of our stars, only the masks themselves.' This anti-psychological approach makes Avedon's *Nothing Personal* seem earnest, but where does it leave Bailey's *Box*?

In Michelangelo Antonioni's cult film *Blow-Up* (1966), the central character (purportedly based on Bailey) finds himself unable to distinguish between reality and illusion. It seems that, in the real world, Bailey had no such difficulty. He spoke of the difference between the person and their fashion image, 'With Jean it's her waifishness ... with Susan Murray it's her sensitiveness ... I sometimes hate what I'm doing to girls. It turns them from human beings to objects. They come to believe they are actually like I photograph them.' Journalist Francis Wyndham quoted Bailey in his text accompanying the *Box*, 'I want to do a book about image. Jean's an image', and wrote about how this 'image' exists as an entity independent of the model. Mellor suggests that Bailey's description of his work as 'styleless' refers not so much to the direct approach of Avedon's psychologically loaded photographs, but to the influence of Warhol's 'cold imagery', where faces mask voids. Indeed, Bailey's *Box* seems more about surface than psyche, more about persona than the person, as seen in *Michael Caine* (page 35), where the actor is depicted as Harry Palmer. The theme continues in Bailey's next book of portraits, *Goodbye Baby & Amen: A Saraband for the Sixties* (1969), with *Sharon Tate and Roman Polanski* (page 47) as The Lovers, and *Jane Birkin* (page 45) as Botticelli's Venus. Peter Evans writes in his text for *Goodbye Baby & Amen*, 'Distance, the enlarger of myth and courier of fantasy, is still to mint the million flawed transparencies that will finally counterfeit the Sixties.' Forty years on, it seems clear that Bailey's photographs from the *Box* and (perhaps to a lesser extent) the ensuing *Goodbye Baby & Amen*, formed much of the iconography that created the spectacle of the 1960s.

As the 1960s drew to a close, Bailey's portraits reflected a broadening of his stylistic repertoire. In these works, he seems to push against the confines of

the *Box* and the studio setting. Instead of situating his subjects in a void, they are now defined by their context. There is an impulse to photograph people at home, at work, or in some other personal environment. The change suggests that the temptation to scratch beneath the surface proved irresistible. Harrison observes that Bailey's portraits of the late 1960s – specifically those of Barry Humphries, David Frost and Kenneth Tynan – 'demonstrate a concern to expose the vulnerability that lay behind the mask of public figures'. This tendency continues into the 1970s and beyond. Indeed it remains evident in much later portraiture. In *Jean-Michel Basquiat* (page 65), he uses the studio backdrop and the artist's body language to hint at the turmoil of creative genius. On the whole his approach remains honorific, as exemplified by the dignity seen in *Brassaï* (page 57) and the respectful treatment of *Peter Beard* (page 97). Each of these portraits exhibits a manipulation of surface so as to plumb psychological depths.

The tension between surface and depth, reality and illusion, has incited much controversy in another area of Bailey's oeuvre. From the 1970s onwards he started to produce a body of imagery taken alongside his commercial fashion photographs: a private project consisting of nude and erotic studies of his models, who more often than not were also his wives. Marie Helvin, whom he married in 1975, is his muse for the book *David Bailey's Trouble and Strife* (1980) – also published under the title *Mrs David Bailey* for countries unfamiliar with cockney rhyming slang. Catherine Dyer, Bailey's wife since 1985, dominates his two books *Nudes 1981–1984* (1984) and *The Lady is a Tramp: Portraits of Catherine Bailey* (1995). Although *Trouble and Strife* appeared at the height of the feminist movement, it was the later books (doubtless due to their more explicit content) that met with greater outrage. Critics decried the way in which

these women were portrayed. As the late writer and jazz musician George Melly observed, 'Not content to marry or live with some of the most beautiful women of our time, he chose to photograph them as sex objects … and to let us in on it.' In *The Lady is a Tramp*, friend and author Fay Weldon was compelled to ask Catherine, 'You don't feel used in any way, taken advantage of? Objectivized? In thus being nailed and made public on the page?'

From the outset, Bailey has attracted accusations of misogyny and exploitation. He would often talk about women in the fashion world, particularly his models, in inflammatory terms. 'I pioneered badness,' he recently told a journalist for *The Sunday Times*, 'I did diabolical things. Awful … I had to cope with these women with no visual sense getting hysterical about some "amusing" little seam.' When talking to an *Evening Standard* journalist about photographing women he said, 'It gives me a terrific feeling of power. Power and destruction.' However, what caused greater indignation was the way in which women in his early fashion shots were stilled under his unashamed male gaze. Before Bailey, the industry photographers were 'tall, thin and camp,' as his contemporary, Brian Duffy, once quipped. To them, models were more like mannequins than women, but to Bailey (along with Duffy and Terence Donovan, or 'The Terrible Three') models were potential conquests. The switch from homosexual to heterosexual gaze resulted in a newly-found chemistry on the page. *Jean Shrimpton* (page 17) captures the model responding flirtatiously to Bailey and epitomizes the dynamic rapport of-ten set up between her and the viewer. Bailey once joked of the editors at Vogue, '[they] said I wouldn't be a fashion photographer because I didn't have my head in a cloud of pink chiffon. They forgot about one thing. I loved to look at women.' This passion for 'looking' reached new heights in his nude and erotic studies.

The photographic medium is of primary importance in Bailey's nudes. He clearly understands how its aura of reality is uniquely titillating: 'The nude in photography is more powerful than in painting because the viewer knows it is a fact and did happen.' When this effect, this immediacy, is combined with the male gaze in the context of fashion photography the result is charged, but when the woman is undressed or sexualized, this rapport verges on voyeurism. The way in which a nude model meets Bailey's gaze becomes tinged with the erotic. Unwavering eye contact, as seen in *Marie Helvin* (page 49), becomes a challenge to the viewer to look at the portrait, whereas the turned head in *Catherine Bailey* (page 87) becomes an open invitation. However, despite the seeming reality afforded by the medium and these photographs' intimate content, Bailey's nudes remain distant. In *Catherine Bailey* (page 99), by privileging form over flesh, he renders his wife as an abstract sculpture, rather than as a living and breathing woman. Indeed Weldon argues that Bailey's photographs turn Catherine 'totally into object, make her one with rock, stones, lumps of wood'. Bailey shuns reality in his study *Scratched Nude with Fish* (page 55). By scratching and scoring its surface, he draws attention to the photographic process and reminds the viewer that the image in front of them is an object, not a window onto the world. In another approach, much in evidence in *Nudes*, he stages scenes to appear manifestly unreal: women are trussed up in barbed wire or smeared with latex, their faces covered by masks or wrapped in bandages. These devices – emphasizing form over content, tampering with the photographic surface and creating highly choreographed tableaux – serve to remove his nudes from reality and place them in a darkly erotic dreamscape or, as Muir proposed, 'the *mise-en-scène* of an eroto-surrealist filmmaker'.

The publication of *The Lady is a Tramp* in 1995 reflected Bailey's diversification into another photographic genre. The previous decade was a watershed for Bailey in that he became a father; 1985 marked the arrival of Paloma, who was named after Picasso's daughter, and 1987 saw the birth of Fenton — namesake of Roger Fenton, Bailey's favourite English photographer (Sascha, his second son, did not follow until 1995). This development spawned his next project: an account of his private life in photographs or, as Catherine terms them, 'family snaps'. Roughly half of the photos in *The Lady is a Tramp* are of Catherine and the children. Bailey claims that it 'is probably the best book I have ever done [and] the most personal'. Yet to interpret 'personal' as 'intimate' would be wrong. The photographs of Catherine in labour with Paloma exhibit some of the coolness of his nudes. They seem immersed in a formalist aesthetic — privileging the arrangement of shapes and tones over lover, wife and mother — establishing distance during intensely private moments. Moreover, one should not assume these family snapshots constitute a glimpse into the reality of the Bailey household. The photographs of the children in this book always show them in one disguise or another. In *Fenton Bailey with Sword* (page 88), for example, the young boy is helmeted, armoured, like an Arthurian knight brandishing Excalibur. The style has continued into the 1990s, as seen in *Sascha Bailey* (page 109), where the younger son looks like an extra from the children's gangster film, *Bugsy Malone*. The endless raid on the dressing-up box would not be out of place in a fashion shoot, resulting in family snapshots that Bailey has composed to appear more surreal than real. When Weldon asked, 'But snaps aren't art. Are they?' Catherine replied, 'They are if Bailey is snapping.'

Bailey has, throughout his career, explored the expressive possibilities of documentary and reportage. By the close of the 1970s he had published a book

of documentary photographs (*Another Image: Papua New Guinea*, 1975) and completed three television documentaries (on photographer Cecil Beaton, film director Luchino Visconti, and Andy Warhol; the latter was infamously banned for including Brigid Polk's *Tit Paintings* and for showing Bailey in bed naked with the star). He had also completed his first major photojournalistic trip: a report on the plight of the Vietnamese Boat People in Hong Kong in 1979. The following decade witnessed Bailey building considerably on this work. Of particular note is his record of the famine in the Sudan in 1985, as seen in *Ethiopian Refugees* (pages 71 and 73). He also embarked on two substantial documentary projects: one recording the buildings in his London borough before they were eroded by city development schemes (published in his book *London NW1*, 1982), the other documenting Welsh valley communities in the face of escalating unemployment and poverty. These projects firmly established Bailey within the documentary genre, and it remained a significant part of his output, both in television (as with his series 'Models Close Up', 1998) and in photography (the book *Havana*, 2006 – one image from which can be seen on page 118).

At first glance, Bailey's documentary photography and reportage might seem at odds with the artifice and subjectivity of his family snapshots and nudes, as well as fashion and the *Box* portraits. Indeed he reinforces this contrast by dividing his work into 'seeing pictures' and 'construction pictures'. He says, 'Seeing pictures are to me people, places and things that are in their own space and not rearranged by the eye. They have a sense of innocence, of just being.' He categorizes his documentary photographs as 'seeing pictures', whereas his fashion shots, nudes and, arguably, the portraits he calls his 'construction pictures'. The description 'seeing pictures' suggests a privileged connection to

reality. However, to read Bailey's move into documentary photography as a move into realism would be misguided. His documentary imagery has much in common with the highly subjective style of one of Britain's most celebrated photographers – Bill Brandt. The older photographer is notable for his manipulation of light and dark to create a dramatic atmosphere: 'Thus it was I found atmosphere to be the spell that charged the commonplace with beauty.' Bailey has remarked how Brandt's work has 'a quality that reminds one of Ingmar Bergman's films, *The Seventh Seal* especially'. The Swedish director likewise used lighting to dramatic effect. However, Bailey is particularly impressed with the way in which Brandt's photographs appear like 'clips from old movies ... you feel like you are seeing part of the story', and (presumably referring to Brandt's image Mayfair, from 1936) 'can never help wondering what's going on in that house where the maid is pulling down the window blinds.' The same sense of narrative can be seen in Bailey's documentary work. The chiaroscuro in his landscape *Lewis Merthyr Colliery, Trehafod* (page 66) creates a foreboding atmosphere and, even though the frame is empty of people, an urgent eye stares out from a poster, willing something to happen. One can only speculate as to whether Bailey intentionally loads these documentary photographs with historical references, to help us recognize them as interpretations of reality. Even in these so-called 'seeing pictures', Bailey's subjectivity colours his documentary; these photographs are very much his views of reality.

In his books *Goodbye Baby & Amen* and *If We Shadows* (1992), Bailey has used the words of Puck, Shakespeare's 'shrewd and knavish sprite', to speak on his photographs' behalf and to offer a suggestion as to where to place his work: 'If we shadows have offended, Think but this, and all is mended, That you have

but slumber'd here, While these visions did appear.' David Bailey situates his photography – from fashion to documentary, family snapshots to nudes, portraiture to reportage – somewhere between substance and shadow, surface and depth, reality and illusion.

**Jean Shrimpton, 1962.** This shot marks the start of Bailey's experiments with techniques intended to, in his words, 'loosen things up'. He worked to develop a new repertoire of poses for Shrimpton, using geometrical positioning of her limbs, or hair in flight, blurred, to lend a sense of movement to his photographs. The tight crop of this image not only adds to the drama of the composition, but also implies action beyond the frame. Moreover, the gaze is unambiguously male: Shrimpton is portrayed as a seductive woman. This photograph represents Bailey's first steps towards the dynamic and sexualized approach that was to set him apart from his *Vogue* predecessors, whom he accused of living 'in a cloud of pink chiffon'.

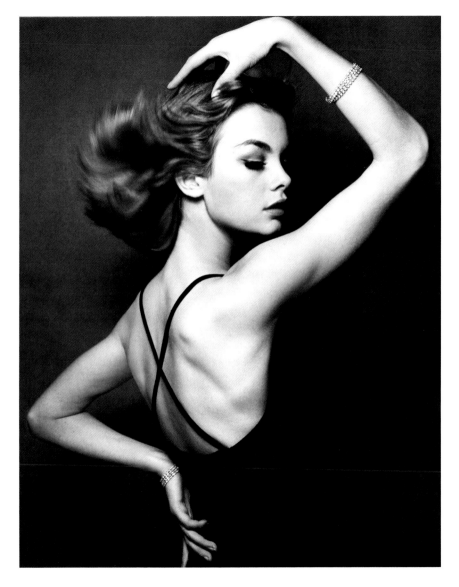

**Pauline Boty, 1964.** The most striking aspect of this portrait of artist Pauline Boty is its unsettling composition. Bailey was inspired by the off-kilter imagery in Elia Kazan's film, *East of Eden* (1955). According to Kazan, his cinematographer Ted McCord tilted the camera to eliminate 'dead' space within the frame. In this photograph, the same device creates a sense of claustrophobia. The depth of this scene combines with the tilted camera angle to suck the viewer's focus down into the room. By positioning Boty's face close to the lens, Bailey further exaggerates this sense of depth and, by placing the canvas at the back of the room and having it held at an incline so it appears almost upright in the frame, he intensifies the viewer's disorientation.

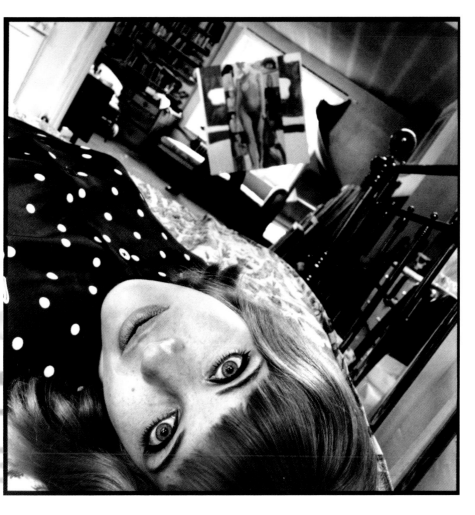

**Mick Jagger, 1964.** Bailey said of his *Box of Pin-Ups*, 'I want to do a book about images.' None would become more iconic than this: the rock star in all his insolent, androgynous glory. Jagger's frontal pose appears direct, lacking the artificial posturing of fashion photography. Bailey also developed a lighting technique that broke with convention. Whereas, in their studio portraits, Irving Penn opted for natural light and Richard Avedon tended to use reflected flash, Bailey lit his subjects with direct flash. This glamorizes Jagger – giving him the flawless, luminous skin of a model – while simultaneously creating a clinical, cold aesthetic, softened somewhat by his fur-edged hood. Under its glare the white paper backdrop vanishes. Jagger is caught in a void: he is transformed into a pin-up, an icon.

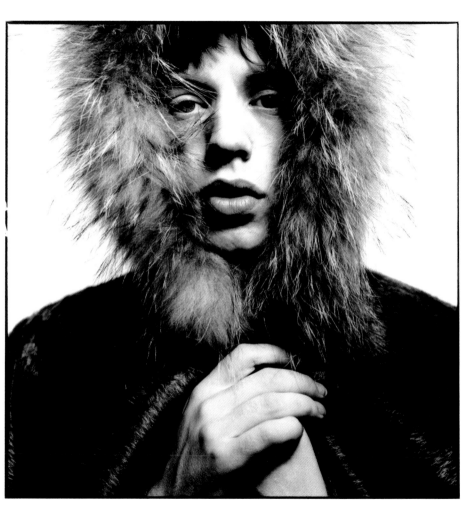

**John Lennon and Paul McCartney, 1965.** The Beatles cultivated what British director Jonathan Miller described as the 'Midwich Cuckoo' stare, in reference to the fictional children with expressionless faces and eyes gazing without focus in John Wyndham's 1957 novel. The look is central to this image, and pop stars were not the only subjects to adopt it in Bailey's *Box of Pin-Ups*. His trademark empty backdrop, by reducing all depth in the frame, draws attention to the subjects' faces and demands the viewer engage with them. Staring out listlessly at the viewer, Lennon and McCartney themselves seem distant, indifferent, or as Francis Wyndham wrote in the text accompanying the *Box*, 'isolated, invulnerable ... self-sufficient'.

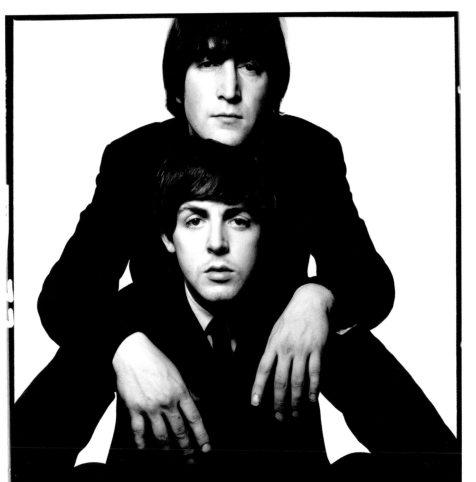

**Cecil Beaton and Rudolf Nureyev, 1965.** This portrait of two twentieth-century legends captures a passing moment between two generations, with the established photographer standing over the incoming ballet star. Beaton admired Bailey and wrote an article about him for *Vogue* in May 1963 that reads as a homage. However, he also voiced one mild criticism: 'Perhaps he's the tiniest bit too definite and arrives with a preconceived idea of what you are like and makes you conform to that.' If this is the case, this photograph can be read as Bailey's homage to Beaton: the older man appears sophisticated and distinguished, and in his pairing with Nureyev, he is presented as a benign patriarch, fostering the next generation.

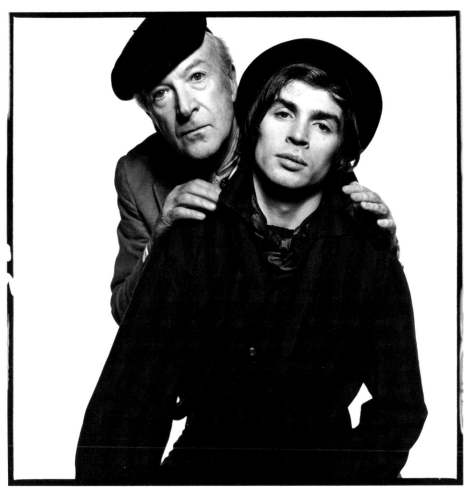

**Andy Warhol, 1965.** If *Box of Pin-Ups* had looked beyond the cultural milieu of 1960s London in its search for movers and shakers, Warhol would surely have featured and this photograph would have been his 'pin-up'. Bailey has occasionally referred to the 'stylelessness' of his photography, a somewhat confusing description given the unmistakable characteristics of most *Box* portraits: their pared-down, high-contrast, graphic quality. Critic David Mellor suggests, however, that by 'stylelessness', Bailey is in fact alluding to what he 'had seen in the cold images of Warhol'. The impersonal iconography apparent in Warhol's *Marilyn* may well have provided the template for Bailey's *Box*. Clearly the avatar of Pop Art profoundly influenced Bailey.

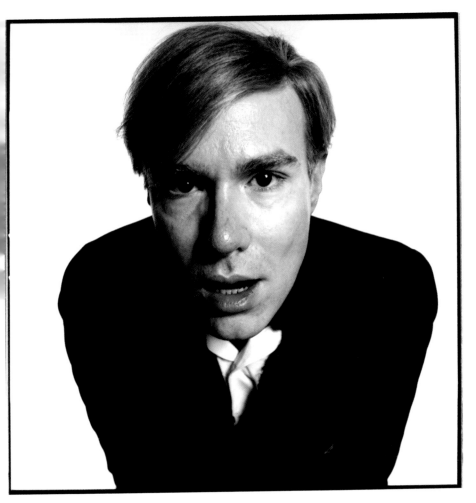

**Catherine Deneuve, 1965.** In 1965, soon after his marriage to Deneuve, Bailey told a journalist, 'I feel it is doomed to success. But I never want to work with her if I can help it. I think that would break it up.' Nevertheless, he took many photographs of his new wife, particularly for magazines such as *Elle* in France, where news of their wedding was eagerly received. This period also sees a move away from the hard-edged, frontal style of *Box of Pin-Ups*. Deneuve appears in soft focus: smoke curls from her cigarette and the folds of her clothes are motion-blurred. Her pose is relaxed, her gaze elsewhere, as if she is unaware of the camera. Bailey's photograph recalls the misty romanticism of early twentieth-century Hollywood glamour photography.

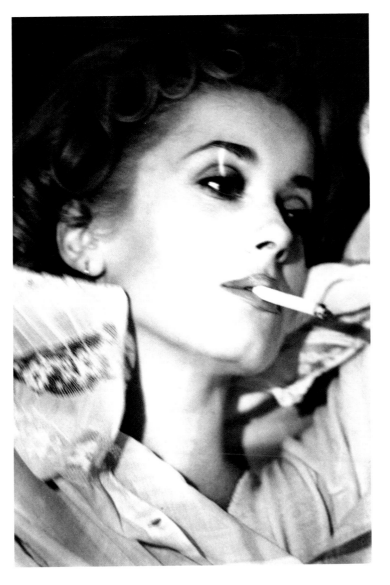

**Jean Shrimpton, 1965.** Bailey took this portrait of Shrimpton especially for *Box of Pin-Ups*. By positioning the camera below her face – eyes fixed, it is suggested, on a world beyond her immediate surroundings – Bailey casts Shrimpton as hero. Indeed, in describing this picture, Francis Wyndham invoked Greek mythology: 'It is possible to see her as Echo in the myth, in love with some Narcissus (David Bailey, Terence Stamp) absorbed in his own reflection. But Bailey says that she is Narcissus.' Wyndham was not the first to recognize that vanity and photography are frequent companions. French poet Charles Baudelaire said of the newly-invented daguerreotype, 'From that moment on our squalid society rushed, Narcissus to man, to gaze at its trivial image.'

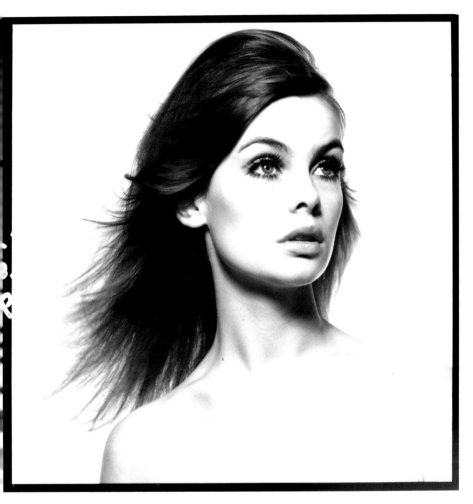

**Peter Ustinov, 1965.** In this dramatic photograph, Bailey has used a fill-in flash to throw a narrow beam of light on to actor Peter Ustinov's face and draw it out of the gloom. The idea came from Ingmar Bergman's film *The Seventh Seal* (1956), where cinematographer Gunnar Fischer over-lit Death's face to create a bright, mask-like visage. This image has also been convincingly compared to Bill Brandt's *Portrait of a Young Girl, Eaton Place* (1955). Not only does it reveal a Brandt-like devotion to chiaroscuro, but, compositionally, the photographs are very similar. The subjects of both are close to the lens, creating a confusion of scale and heightened feeling of depth. Bailey has further accentuated this sense of dislocation by tilting his camera.

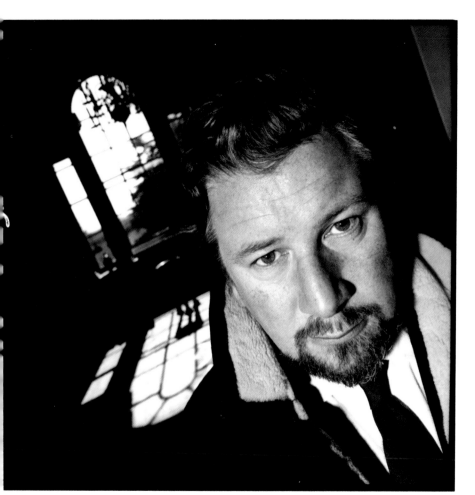

**Michael Caine, 1965.** Bailey took this portrait two months after the London premiere of The *Ipcress File*, the film that would immortalize Caine as cockney spy, Harry Palmer. Bailey asked Caine to assume the Palmer persona – sharp suit, horn-rimmed glasses, trademark Gauloise, ego pushing against the confines of the frame – and created one of the most iconic photographs of the 1960s. The image has been endlessly restaged: even by Bailey, with Jude Law standing in for Caine, in the same style of suit and tie, holding a cigarette between his lips in the same way. When it comes to using pose, look and props to create a persona, Bailey has the eye of a master casting director.

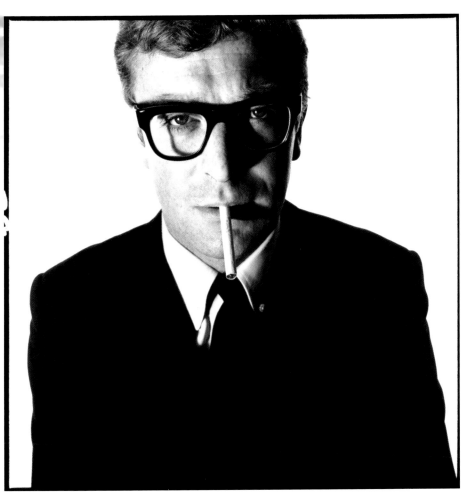

**Balenciaga Dress, 1967.** This image is from a series Bailey shot for American *Vogue* called 'Balenciaga's Marvels of Form'. The dresses, designed by Spanish couturier Cristóbal Balenciaga, are sculptural and Bailey has chosen to portray them as stark and monumental. Sometimes, as is shown here, a model's arms and gloved hands accentuate a line or a fold. Occasionally the back of a head and neck (but never a face) appears. Otherwise, the dresses are the visual focus. The photographic style recalls the work of Irving Penn. The image has a subtly graded tonal range and Bailey has lit the scene to register wrinkles on the floor of the studio and shadows on the wall, providing more context than his signature bleached-out white backdrops.

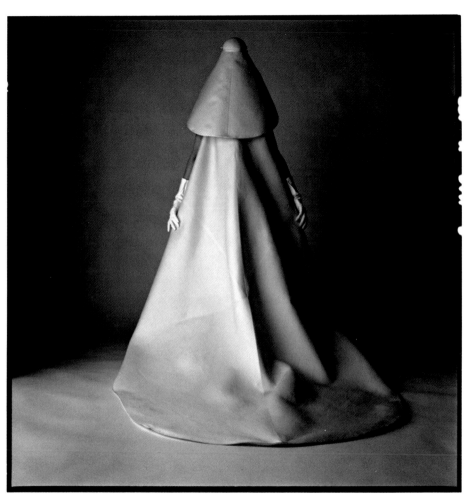

**Brigitte Bardot, 1967**. Bailey took this image during a shoot with Bardot for *Elle* magazine. It appears in his second book, *Goodbye Baby & Amen*, as shown here: cropped so aggressively that Bardot's face fills the frame — a close close-up. *Goodbye Baby* marked a departure from the style of portraiture in *Box of Pin-Ups*; many of the women featured, for example, were photographed through textured gauze or using lens filters that softened the image. Here the resulting, high-contrast composition hovers between abstraction and intimacy, highlighting Bardot's sultry gaze.

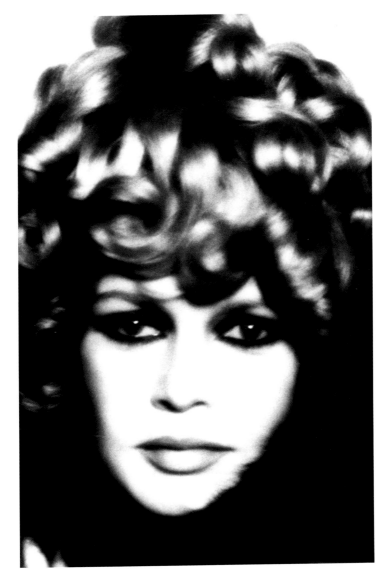

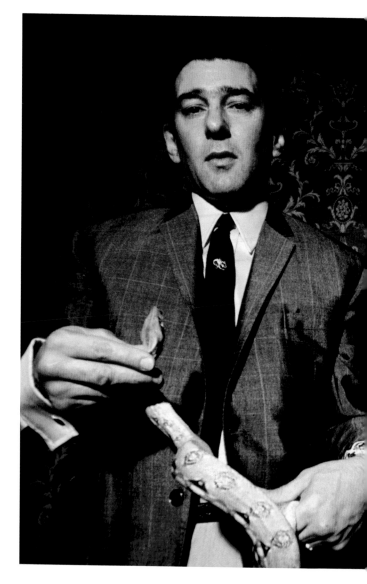

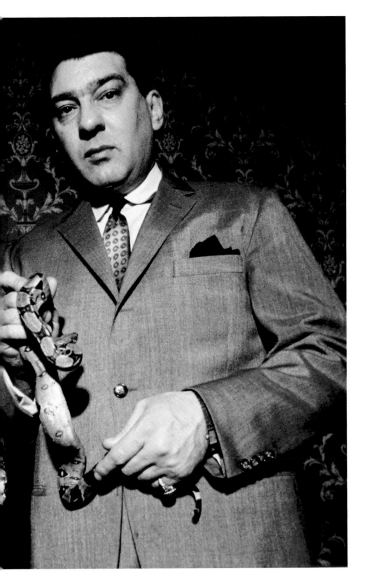

(previous page) **Kray Twins with Pet Snakes, 1968.** Bailey has been accused of giving notorious East End gangsters the Kray twins a veneer of respectability in his photographs. He claims, 'I did a lot [of pictures] of the Krays. I vaguely knew them as a kid in the East End – not personally but I used to go to dance halls where they'd appear.' He took this portrait of Ronnie (right) and Reggie (left) for a *Sunday Times Magazine* story called 'East End Faces'. Their dapper suits, the flock wallpaper, even the tenderness evident in the way they handle their pets Gerrard and Nipper, combine to make these cold-blooded criminals seem camp, almost comic. The image never made it to press; shortly before publication the twins were arrested for murder.

**Man Ray, 1968.** Bailey made this portrait of Man Ray during two days they spent together in London in 1968. It was their first meeting and, although Bailey had great respect for the surrealist artist, he later called him, 'grumpy and self-opinionated ... His intelligence was in his eyes rather than his mouth.' In this image, Man Ray's eyes glare through his specs, his thick dark eyebrows are raised in challenge and there is no evidence of a smile tweaking the corners of his lips. It seems a photographic imprint of Bailey's recollection of their meeting; indeed he selected the image from a contact sheet that presented several, more playful, alternatives.

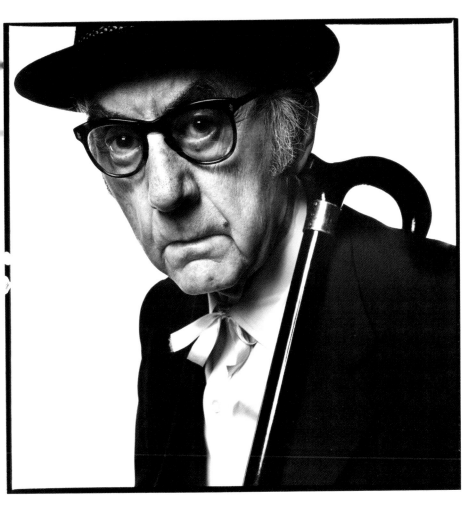

**Jane Birkin, 1969**. This portrait of Birkin was taken in the year she and her lover Serge Gainsbourg caused uproar with their explicit duet, *Je t'aime … moi non plus*. In *Goodbye Baby & Amen*, journalist Peter Evans wrote alongside this image, Birkin is a 'purveyor of erotic emaciation … providing altogether a rather better bone display than the Natural History Museum'. Bailey's aspirations, however, were grander. Birkin's flyaway hair, angled left shoulder and the hands raised to her breast recall the goddess in Botticelli's painting, *The Birth of Venus* (c.1484). Bailey has cast Birkin as a deity incarnate, the most sublime and seductive woman on earth.

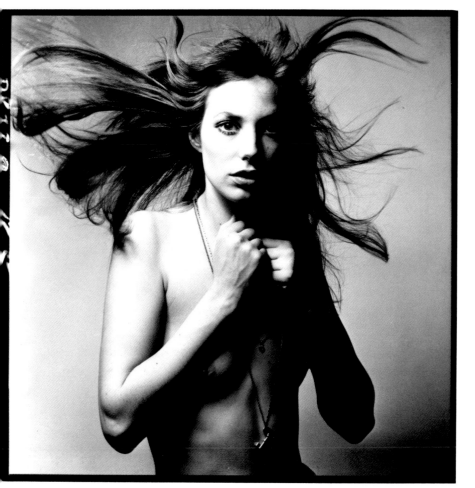

**Sharon Tate And Roman Polanski, 1969**. Peter Evans described these infamous lovers as 'part of the anti-Establishment Establishment ... Anyone interested in the history of the Sixties and the Permissive Society must consider the Polanskis.' They courted scandal; their lifestyle endorsed drugs and sexual freedom. Yet this portrait seems to paint an intimate, 'behind-the-scenes' picture. Whereas Bailey's iconic, posturing pin-ups exude attitude, here he appears to have captured a candid and tender moment: the loving couple in a gentle embrace. Their expressions appear earnest, their eyes guileless.

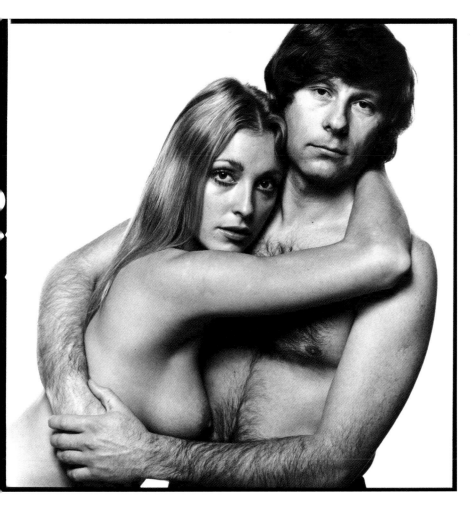

**Marie Helvin, 1976.** Bailey published his photographs of third wife Marie Helvin under the title *David Bailey's Trouble and Strife*. On the nude studies, he said, 'They have a starkness that somehow belongs to the 1970s. There seems to be a lack of nostalgia about them.' However, this particular example shares similarities with a photograph made forty years previously — Edward Weston's image of Charis Wilson on the sand: *Nude* (1936). Both have an abstract simplicity, with Helvin and Wilson carefully arranged to appear like sculptures. Crisp highlights and shadows delineate the women's bodies against flat, grey backgrounds. However, a fundamental difference can be seen: whereas Wilson hides her head in her arms, Helvin challenges the viewer with direct, unwavering eye contact.

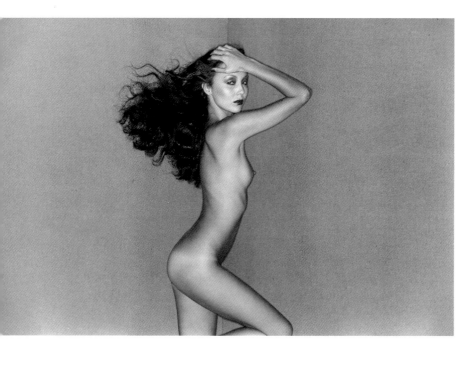

**Aerated Bread Company's shop, Camden Road, c.1981.** Bailey's book *London NW1* – documenting the buildings around London's Primrose Hill, where he used to live – opens with this image. A departure from the meticulously choreographed style of his celebrity portraits, it hints at the cool, detached imagery of late twentieth-century photographers such as Bernd and Hilla Becher. However, it lacks the Bechers' commitment to preventing their subjectivity tainting the object. By making this exposure as shadows begin to creep over the shopfront, and by accentuating the scene's sombre lighting during the printing process, Bailey has created an atmosphere of dereliction. Indeed, by the time the book went to press, this 1930s facade had been torn down.

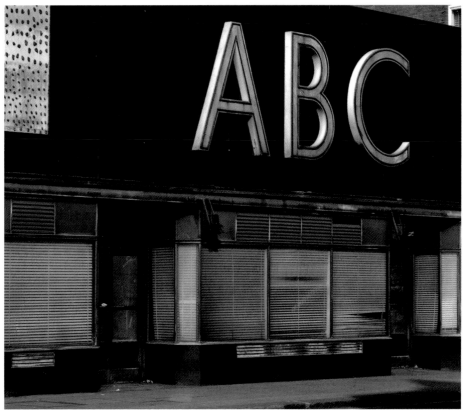

**Jacques-Henri Lartigue, 1982.** Bailey befriended Lartigue and his wife Florette in 1970. He was a great admirer of the older artist, saying, 'It's impossible to place Lartigue in any photographic school.' However, others often label Lartigue 'Master of the Snapshot' to reflect the flying, leaping, dancing dynamism that unites his photographs. The unflinching glare of Bailey's camera reveals a face lined and hands liver-spotted by the years, yet Bailey, in Lartigue's look of feigned surprise, manages to capture the energy that defined the maestro's work. Lartigue died four years after this sitting, soon after his ninety-second birthday.

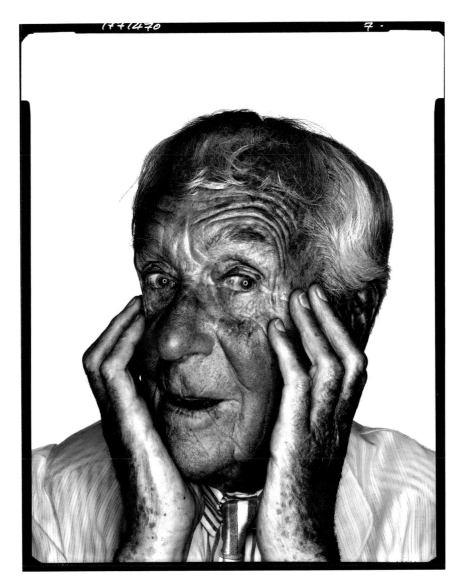

**Scratched Nude with Fish, 1983.** The original version of this photograph, taken on a shoot for the Lamb's Navy Rum calendar, shows model Lorraine Coe in full Caribbean colour, without marks and scratches. This altered version owes a debt to a master of the photographic nude, E.J. Bellocq. No one knows why Bellocq scratched out the faces in his portraits of the *Storyville* prostitutes of New Orleans (1912), but Bailey's markings, similarly, obliterate Coe's gaze. The effect is to give the viewer unchallenged visual access to the woman's body.

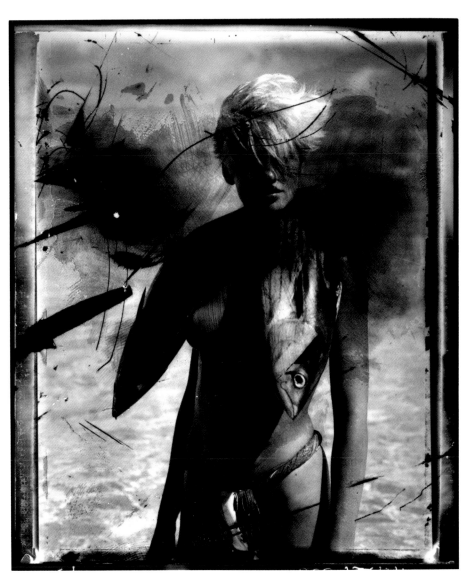

**Brassaï, 1983.** Bailey travelled to Nice to meet Brassaï the year before he died. The result was this portrait, taken on the balcony at Brassaï's home. The darkening skies and inky shadows create a crepuscular atmosphere; which is apt given that Brassaï is best known for *Paris by Night*, a photobook documenting his nocturnal wanderings through 1930s Paris. Bailey made the trip following the publication of Brassaï's lesser-known book, *The Artists of My Life*, in which he photographs Bailey's greatest hero, Picasso. Bailey had various opportunities to photograph Picasso but always avoided the task: 'Maybe I just wanted to preserve the myth and not turn it into a picture.' However, in this respectfully composed portrait he honours the man who did.

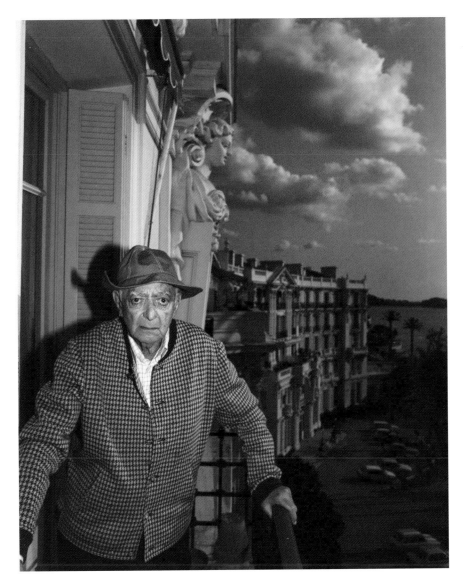

**Catherine Bailey, 1984.** Bailey occasionally experiments with masks; either actual prosthetics or, as in this case, a disguise of wigs, make-up and costume. This masquerade calls to mind the highly theatrical self-portraits taken by surrealist photographer Claude Cahun in the 1920s and 1930s. Cahun wielded the mask as a device to imply that identity is a performance — a role rather than a truth — saying, 'Under the mask is another mask, I will never finish lifting off all these faces.' In this photograph, Bailey has rendered his wife in a playful *trompe-l'oeil* that not only confuses notions of gender and identity, but also pays homage to the cubist works of his hero, Picasso.

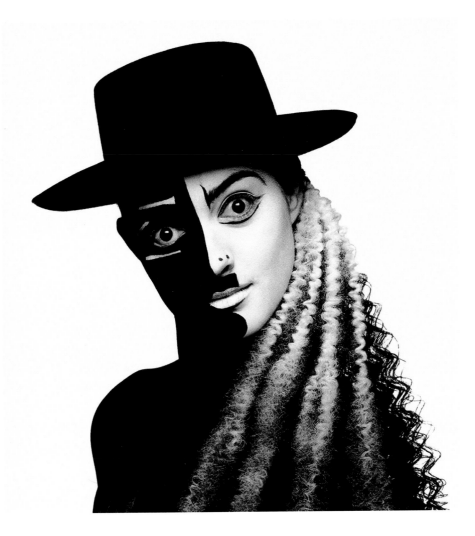

**Catherine Bailey, 1984.** This vision of female crucifixion is a potent mix of two powerful cultural motifs: the image of Christ crucified and the woman's body. The first image is intended to elicit feelings of piety, whereas the other can be suggestive, even erotic. In this photograph, Catherine appears with bare torso, arms outstretched, head nodded to her chest, provocatively cast as the crucified Christ. The iconography is far from traditional: barbed wire stands in for Christ's crown of thorns; Catherine's blank eyes and bloodied but colourless lips suggest a wraith or demon. The subject of this tableau vacillates between sacrificial lamb and she-devil.

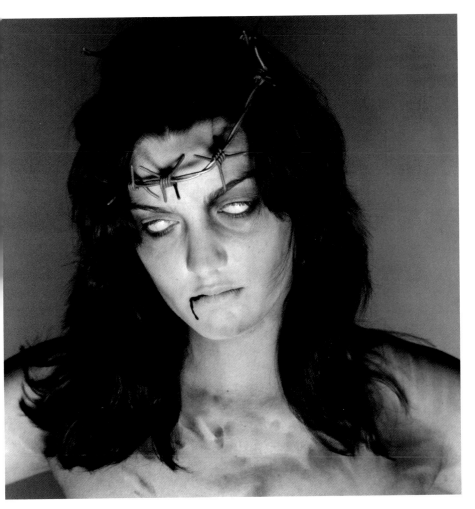

**Jack Nicholson, 1984.** Mouth thrown open, eyebrows rakishly arched, face contorted by laughter; this is not the poise we have come to expect of film stars, yet it conforms to our preconception of Nicholson as Hollywood bad boy. The rapport between the subject and the photographer is evident — the actor is a friend of Bailey's and godfather to his son Fenton. In contrast to the unfocused, blank gaze of the icons in *Box of Pin-Ups*, Nicholson fixes his eyes firmly on the camera. Bailey, by creating a strong shadow across one side of his subject's face, has even emphasized the twinkle in his eye.

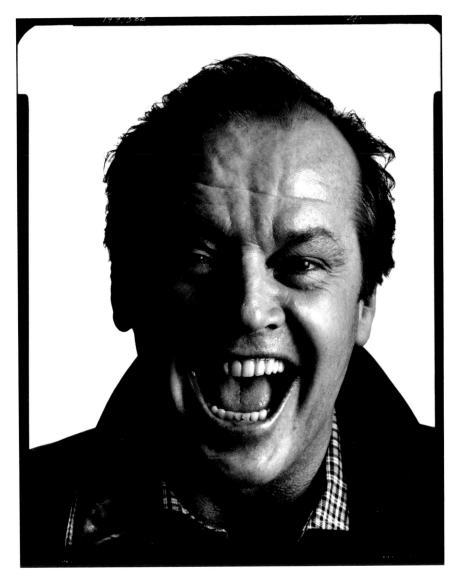

**Jean-Michel Basquiat, 1984.** Adopting a more traditional approach to portraiture, Bailey uses context here to create mood and suggest psychological insight. He has sandwiched the artist between his mask-like paintings and confined him beneath angled canvases, which slice up the surface of the image, to a portion of the frame. This composition, combined with Basquiat's hunched, hands-in-hair pose, suggests an artist suffocated by his work. It is difficult to see this image afresh knowing that, four years after he sat for his portrait, Basquiat would finally fall victim to his long-term drug habit.

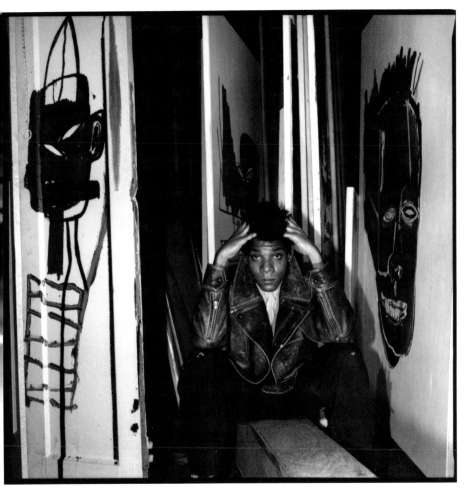

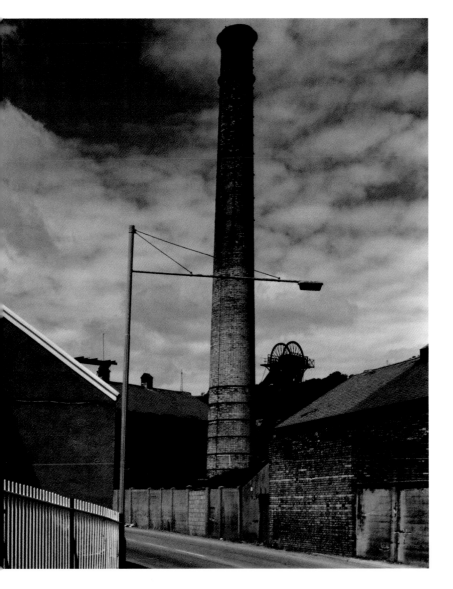

(previous page) **Lewis Merthyr Colliery, Trehafod, 1984.** Many great photographers have been drawn to the Welsh valleys: W. Eugene Smith, Robert Frank and Bruce Davidson, to name but a few. Bailey made his pilgrimage on behalf of Ffotogallery, as part of its five-year survey documenting the problems facing valley communities. This is one of fifty-five images that he took over ten visits. Bearing a striking resemblance to Bill Brandt's earlier photograph, *Halifax* (1937), which captures the manufacturing town during the industrial depression, it contains the same sombre atmosphere, the same aggressive architectural angles, even the same dark, towering chimney. The single staring eye in Bailey's composition also communicates a sense of unease, perhaps even pessimism.

**Rome, 1984.** In 1974, Bailey notoriously told a journalist for *The Image:* '*Vogue* doesn't hire me because I've got a pretty face, they use me because I shift frocks.' A decade later, this image displays the same tactics he employed when he initially reworked the genre – turning fashion into beauty photography. As in *Jean Shrimpton* (page 17), the focus is the elegant, seductive gaze of the model as much as the couture; each glamorizes the other. Women reading *Vogue* react to their counterparts on the page, desiring the dress in as much as it delivers a lifestyle, rather than as a well-cut piece of cloth.

**Ethiopian Refugees, Live Aid, 1985.** The critic Susan Sontag would argue that such images of horror seem like 'an unbearable replay of a now familiar atrocity exhibition', where repeated exposure has made misery less real and anaesthetized our conscience. However, when the BBC first alerted the world to the catastrophic famine ravaging Ethiopia in 1984, such images had the power to shock people into action. Bailey flew out to the Sudan, where he spent a week in refugee camps. Many of the resulting photographs focus on children. The shock of this portrait is not the rags, flies or angular limbs, not even the sore, swollen lips, but the eyes: they return the viewer's gaze with a despondency usually only seen after decades of disappointment.

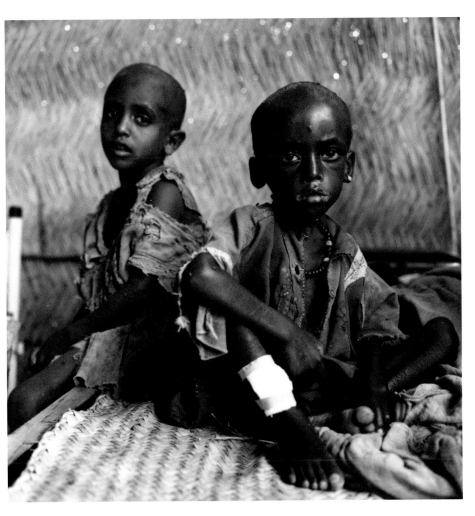

**Ethiopian Refugees, Live Aid, 1985.** This is both a beautiful image and a document of extreme human suffering. The baby, so tiny it could be cupped in a hand, closes its eyes in sleep. Bailey fixes the moment in a careful composition, with tones and shapes starkly graphic – the edges of the frame cropping out context. Bailey wrestles with his conscience when taking pictures of human misery, recognizing 'a Jiminy Cricket saying, "Hold it, Bailey! All you really care about is the image"'. Yet the power of this portrait lies in the dual purpose of the tight framing: it creates a simple aesthetic while simultaneously telling the bleak narrative of a baby separated from the nurturing maternal embrace.

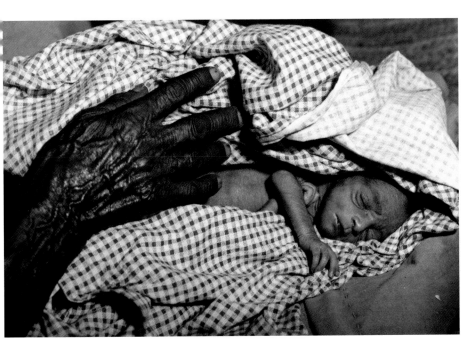

**Catherine Bailey Giving Birth, 1985.** An intensely private moment has been mercilessly recorded here. Catherine is caught with back arched, legs splayed, breasts full. That her face is hidden communicates her oblivion to nurse, doctor, photographer and unborn child, to everything except pain. At this moment Catherine appears more animal than human. She has admitted to the author Fay Weldon that she finds this image difficult to look at. Weldon suggests that because Bailey can never experience childbirth, he uses the photographic process to dissect, demystify and understand it. The shocking clarity of the image doubtless demystifies but, as an aesthetic rendering of form and texture, it manifests distance rather than empathy.

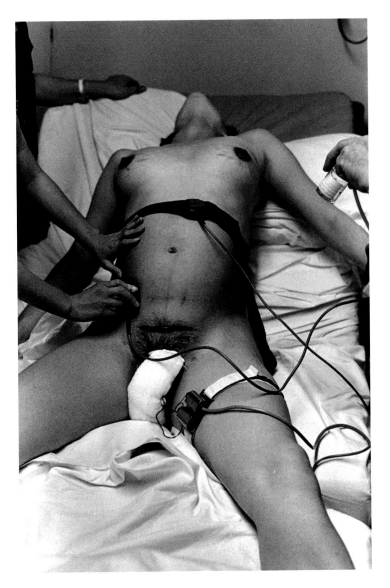

**Paloma Bailey's Birth, 1985.** Suddenly, the private moment of labour becomes public: the baby, Bailey's first child, has emerged and the nurse uses a tube to unblock her nose. Her ribs appear expanded as if she is trying to suck in her first breath before a first exhalation, her first cry. Covered in blood and mucus, she seems primordial, even alien. Behind her, in soft focus, Bailey has shown the spent body of his lover turned mother. Within the composition, Bailey creates an aural, textural and visual experience, his evocation of this intense moment. They named the baby Paloma — as Bailey explained, 'a little debt I had to pay to Pablo [Picasso] for showing me you can invent reality'.

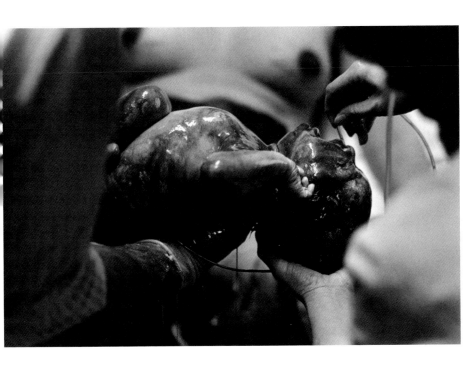

**Catherine Bailey and Susie Bick, 1985.** Upon leaving school, Bailey wanted to become a jazz musician. 'I bought a trumpet and prayed to Chet Baker,' he says. This surreal staging of a jazz set pulses with overtones of the erotic. Catherine, in a figure-hugging, latex vest, spiky earrings and striking make-up looks severe but feminine, whereas Susie has been clothed in an androgynous style. Although the two figures seem unaware of each other, the vignette draws them together. The English jazz singer George Melly said that Bailey's sexualized photographs 'emanate a disturbing poetry'. Here, music stands in place of words; Susie presses her lips to the brass mouthpiece and plays seductive melodies in Catherine's ear.

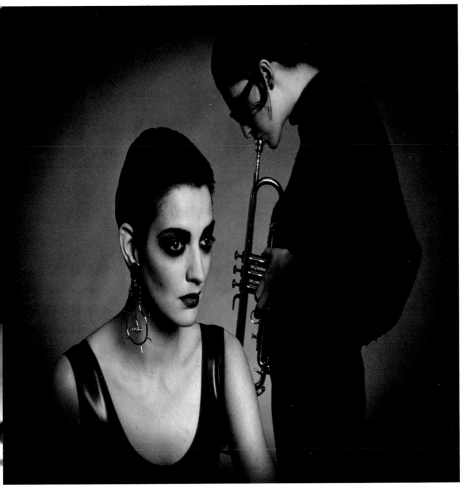

**Catherine and Paloma Bailey, 1986.** Mother and daughter share a moment blowing seeds from a dandelion. The scene appears intimate and casual — a family snapshot — and yet closer inspection reveals highly constructed elements that turn the image from real to surreal. Positioned against the grey canvas of the lawn, the two are separated from their contemporary surroundings and their unusual attire seems Victorian. Catherine is cloaked and crone-like, while Paloma, clutching a dog lead that looks more like a walking stick, appears stooped and frail.

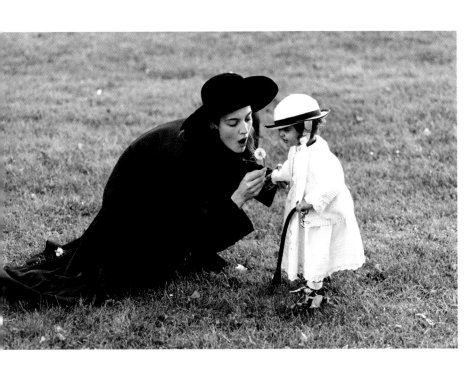

**Catherine Bailey and Angie Hill, 1986.** Catherine (right) has observed that 'a photograph includes the photographer as part of the moment'. This image is as much about the balance of power between the photographer and his subject(s) as it is about the relationship between the two women. Bailey admits that photography gives him a feeling of 'power and destruction' over his models, provoking his critics to accuse him of misogyny. Yet his female subjects seem complicit in acting out his fantasies. Here their demeanour suggests ease and intimacy: Angie is perhaps wary, but Catherine challenging. She says, 'I know what I'm doing. I'm always in control.' This representation of her, in a dominant and masculine role, confuses any reading of Catherine as victim.

**Billy Wilder, 1989.** On making a scene interesting, the Hollywood writer and producer famously quipped, 'If you see a man coming through a doorway, it means nothing. If you see him coming through a window, that is at once interesting.' Bailey, by including a statuette in the frame to mirror the man, delivers a note of comedy himself. Wilder looks as if he has been caught mid-sentence in conversation with the figure.

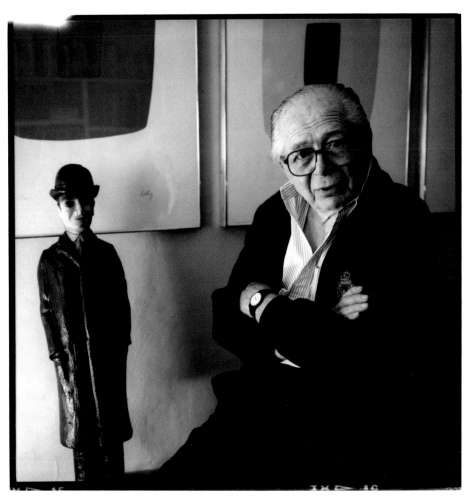

**Catherine Bailey, 1990**. Bailey has photographed his wife as an odalisque, her near-naked body sexualized and supine. This photograph elicits an extra frisson, when compared to historical examples such as Ingres's *Grande Odalisque* (1814), due to its aura of reality. Bailey elaborates on the power of the photographic nude, saying 'the viewer knows it is a fact and did happen'; conversely, no one knows which aspects of Ingres's masterpiece originated in his imagination. However, a fine line divides the pornographic from the artistic. By rendering Catherine's body more alabaster than flesh, Bailey sidesteps the overtly voyeuristic tendencies of the camera.

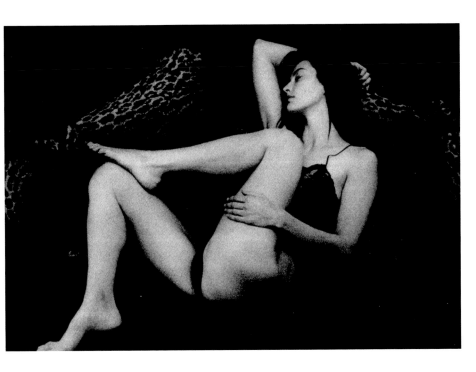

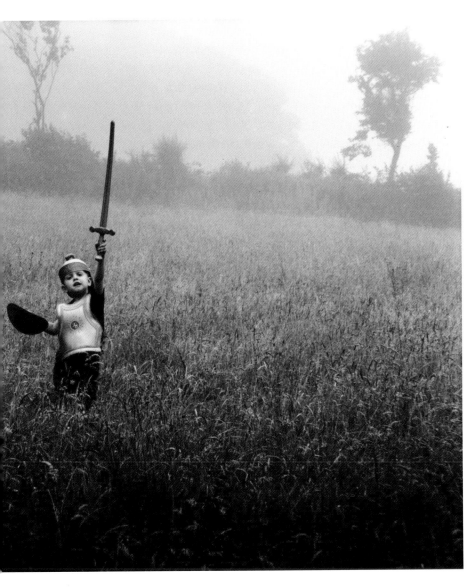

(previous page) **Fenton Bailey with Sword, 1990.** Bailey divides his work into what he calls 'constructed' and 'seeing' pictures. The former are built up from a blank canvas, often in a studio, whereas the latter are images made as he finds them: 'They have a sense of innocence, of just being.' This photograph, showing Bailey's young son Fenton, is unquestionably a 'seeing' picture. It is difficult to imagine anything more stylistically different from Bailey's graphically powerful 'constructed' images; however, the surreal subject matter, the mist hanging over the cornfield and fine tonal gradation combine to create an ethereal otherworld that was no doubt appealing to his 'seeing' eye.

**Untitled, 1995.** As writer and curator Robin Muir observes, Bailey 'has never treated photography and painting as bitter foes. Rather the opposite, he has drawn strengths from their interaction.' For this image, a photograph of Catherine has been overlaid with paint. The earthy, bold pigments, the energetic brushstrokes and the primitive, phallic figure on the left hint at Bailey's responses to his wife's image. However, he leaves her eyes untouched, seeming to grant the viewer direct access to her psyche.

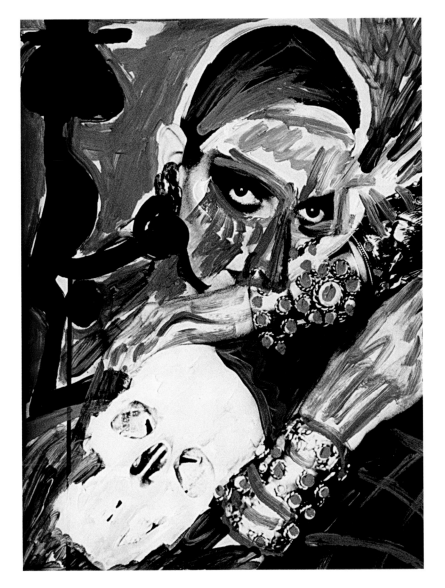

**Ralph Fiennes, 1995.** Richard Avedon notes that whereas a white background empties a scene, 'a dark background fills ... [and] the artist is allowed the romance of a face coming out the dark'. In this photograph, a skull emerges with Fiennes's face; a reference to his performance as Hamlet in the Almeida theatre's 1995 production of the play. This prop – also emblematic of *vanitas* still life paintings from the seventeenth century – symbolizes the transience of earthly existence. Fiennes's hand acts like the surface of still water; the skull is his reflection.

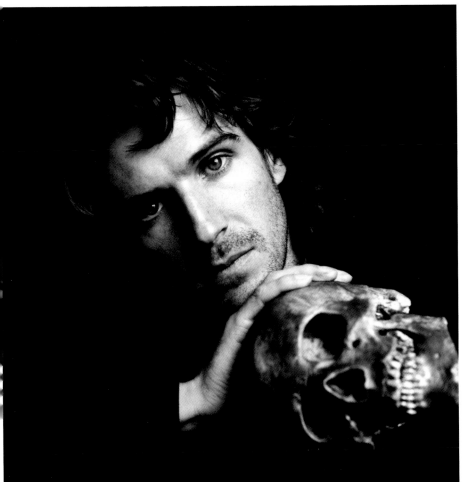

**Johnny Depp, 1995.** This photograph of Depp, taken for *Harper's Bazaar*, was created thirty years after the publication of *Box of Pin-Ups*, and yet, with its bleached-out backdrop, crisp tonality and frontal pose, would not look out of place on the *Box's* opening page. The crop is perhaps tighter, but the result is the same pared-down, powerful, monochrome image. Bailey thinks that the only way you can tell the difference between a shot taken in 1965 and one taken today is by looking at the model. The essence is his rapport with the subject: 'You can't copy it. A lot of people copy [Helmut] Newton, badly, but you can't copy something that's to do with personal chemistry.'

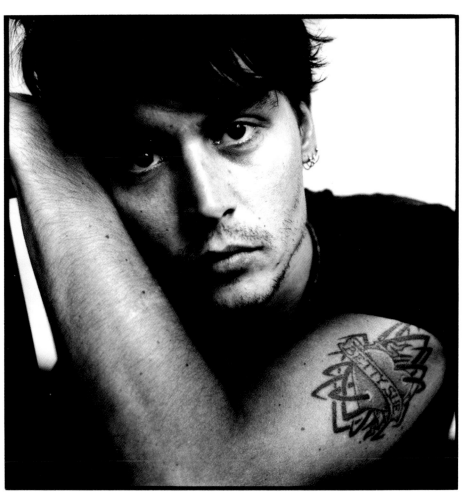

**Peter Beard, 1997.** Bailey took this portrait the year after his friend's first major gallery retrospective and has portrayed him here in his role as artist. Beard's collages fuse drawing, painting, photography and text; the works mix found objects with newspaper clippings, quotes from diaries with literary sources. This image depicts him at work, writing in ink (he has also been known to use blood). Although his papers are spread over the floor, the strong receding lines of Bailey's composition bring an order to the scene. Perhaps Bailey is hinting at his colleague's character; the obvious care Beard takes not to smudge the ink betrays a fastidiousness that is mirrored in his carefully groomed appearance.

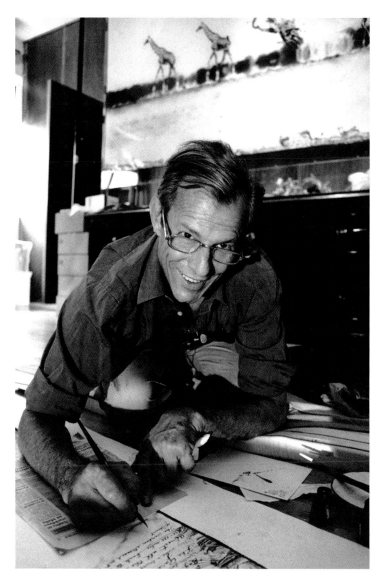

**Catherine Bailey, 1998.** Bailey has rendered his wife's bare torso as an exquisite abstraction: marble carved in relief against a black background. The photograph, as with *Marie Helvin* (page 49), recalls the work of the American modernist photographer, Edward Weston. Weston has been accused of treating the female body in much the same way as he would a vegetable in his search for perfect form; little separates his nudes from his famously aestheticized *Pepper No. 30* (1930). Bailey, likewise, has favoured form over content in this study. Catherine seems more like a cold, stone sculpture than a woman. The lack of eye contact underscores this distance and sense of inanimation.

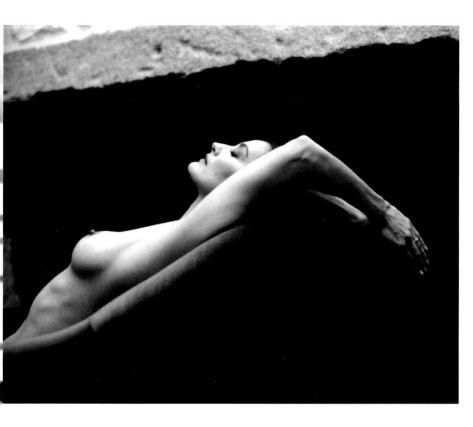

**Tim Burton and Lisa Marie, 1999.** The couple sat for this portrait only a few years after Burton had directed his girlfriend and muse in her memorable role as the mute, gum-chewing, pneumatic Martian in *Mars Attacks!* In this tightly framed, high-contrast image, the viewer's gaze is first drawn along the pale curve of Lisa Marie's breast and hairline, to meet her confident gaze. Burton emerges from the background looking uncertain, almost sheepish. Bailey has captured an asymmetry in the pair: unlike the model and actress, Burton appears unaccustomed to being in front of the lens.

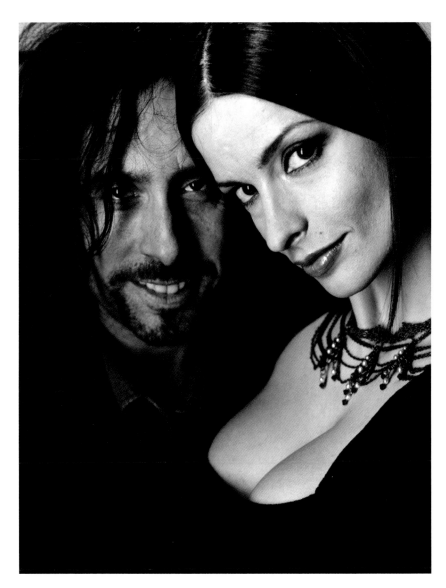

**Marianne Faithfull, 1999.** In an earlier portrait, *Marianne Faithfull* (1964), Bailey immortalized the celebrity as fresh-faced and demure. This photograph, taken forty-five years later, is its antithesis. With tights digging into her waist, her neck tendons strained and dressed in far from brief briefs, she is unflatteringly exposed. On seeing Faithfull strike similar poses for Bailey, journalist Lynn Barber said, 'This is sadism, this is misogyny, this is cruelty to grandmothers.' Faithfull counters, 'I'm so much older. I've stopped caring about beauty, but I still care about truth.' Indeed the image can be interpreted as a brave stand against the falsity of the pin-up.

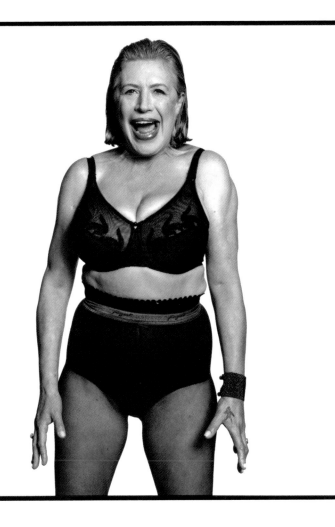

**Bruce Weber, 2000.** In this dynamic photograph, the viewer's eye is drawn to Weber by the receding lines of the Manhattan boardwalk, its wire fence and barricade. He is the darkest object in the frame: a black hole, sucking our gaze inwards. At his chest he holds a twin-lens reflex camera, which enables the photographer to interact with his subject while pressing the shutter. Indeed, Weber may have tripped his shutter just as Bailey took this exposure. The portrait captures the split second in which the great observer is observed. Bailey says of the moment, 'Sometimes the pictures become a message to another photographer. Only [someone like] Bruce Weber is going to understand … sometimes I do my pictures for them.'

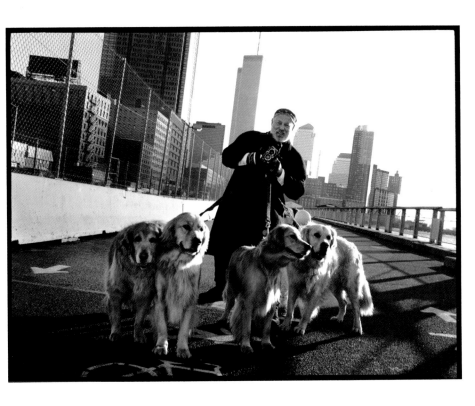

**David Bailey, 2001.** Bailey has turned his camera on himself; he is both the artist and the subject. For once he is not evaluating the character of another, but himself. The viewer tends to analyse, interpret and look to all self-portraits to deliver revelations about the artist's psyche. In fact, by engineering all aspects of the image – from pose to lighting, framing to clothes – the artist is able to portray him (or her) self, not necessarily truthfully, but as they would wish to be seen. Here Bailey shadows half his face, tilts his head downwards and looks up at the lens. He knows that the subject's power to arrest and engage the viewer depends on eye contact. He emerges from this portrait as somewhat self-consciously intense.

**Sascha Bailey, 2001.** Bailey seems to have captured a real, yet surreal moment; a young boy glances in the direction opposite to that of the sign's instruction. The intuition and spontaneity apparent here evoke the work of Bailey's hero, Henri Cartier-Bresson, in the creation of a photographic 'decisive moment'. However, when we know that the subject is Bailey's son, the image begins to read instead as a highly choreographed tableau, in which almost every element is staged: from the deliberately discordant gaze to the *Bugsy Malone*-style costume. A more apt description of this photograph might be what the narrative photographer Les Krims has called an 'anti-decisive' moment.

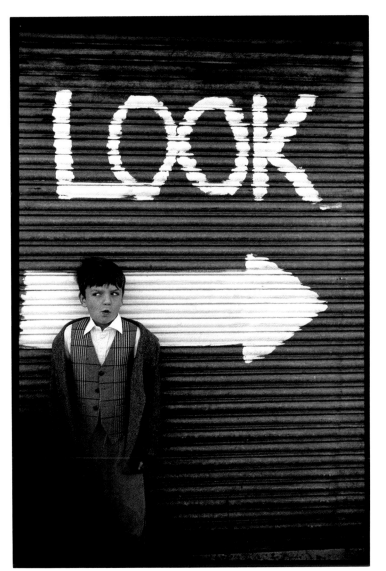

**Don McCullin, 2001.** The great war photographer is famed for images of the destitute and dying, portraying pain with such compassion that one critic labelled his photographs 'crucifixions'. Almost two decades after McCullin retired from war zones, Bailey casts his friend once more as a combatant — sleeves rolled up and ready for action. His expression, however, is serious. His wartime experiences seem etched on his rugged face; its creases and cracks are echoed in the surface of the wall. McCullin has taken up landscape photography, saying, 'I am sentencing myself to peace.' In this shadowed interior, the window of light that falls on his face is raked as if passing through bars; Bailey suggests that McCullin is indeed imprisoned.

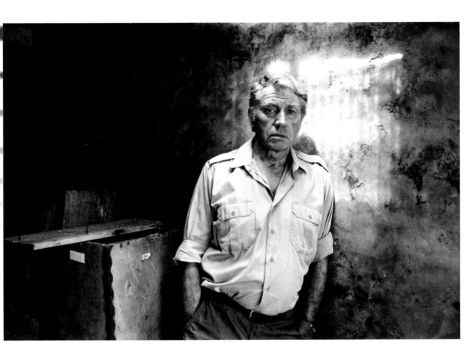

**John Galliano, 2001.** Richard Avedon observed that all portraits are fashion portraits in that they are staged. 'In fashion,' he remarked, 'everything — the entire body, hair, make-up, fabric — is all used to create a performance.' Galliano himself is a master of the fashion-world masquerade. His catwalk creations are so extravagant that they can overwhelm all but the most self-confident model; they require performance. The character that Bailey here fixes on celluloid — plumed like a peacock, strutting and dancing, singing and jangling — is himself lacking in neither nerve nor flamboyance.

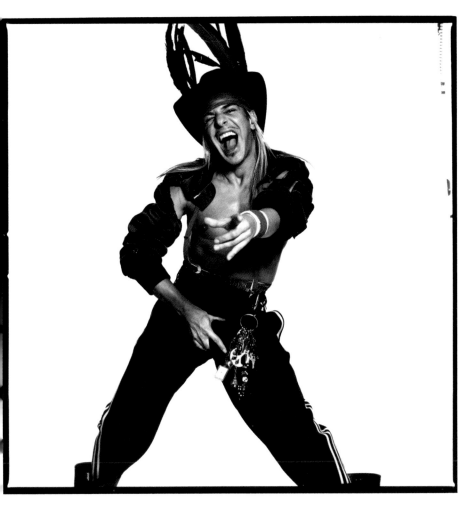

**Julian Schnabel, c.2001.** Schnabel is a friend and admirer of Bailey, and collects the photographer's paintings. In this portrait, the American artist and filmmaker stands in front of *Large Girl with No Eyes* (2001), from his series 'Big Girl Paintings'. In Bailey's composition nothing intrudes on the artist and his work; indeed, Schnabel is framed by his painted subject. Schnabel has blindfolded all the girls in this series, with a swathe of paint drawn across their eyes, prompting critics to call them 'anti-portraits'. By contrast, Bailey uses this device to slice through and highlight Schnabel's eyes, so that we feel the full force of his gaze.

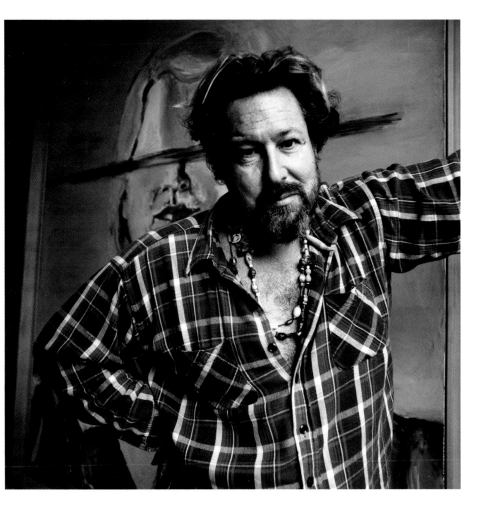

**Cicciolina Goes to Heaven, 2003.** Which aspect of La Cicciolina is portrayed in this photograph? She was born in Hungary as Ilona Staller. She achieved celebrity as the hard-core porn star who was elected to the Italian parliament. Finally, her image was indelibly imprinted on our collective consciousness when she became Jeff Koons's muse. Bailey stages her in beatific terms, winged and haloed, ascending past a star-like light, in a scene as kitsch as the art that defined her. In case the viewer fails to pick up on these visual cues, the photograph's title removes any doubt: Bailey is referring to Koons's *Made in Heaven* – the series that immortalized him and his wife in coitus.

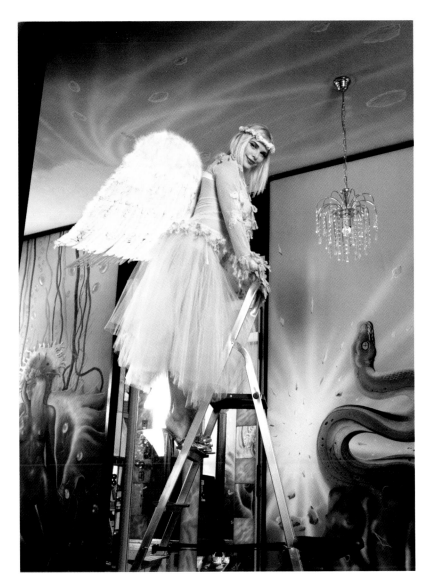

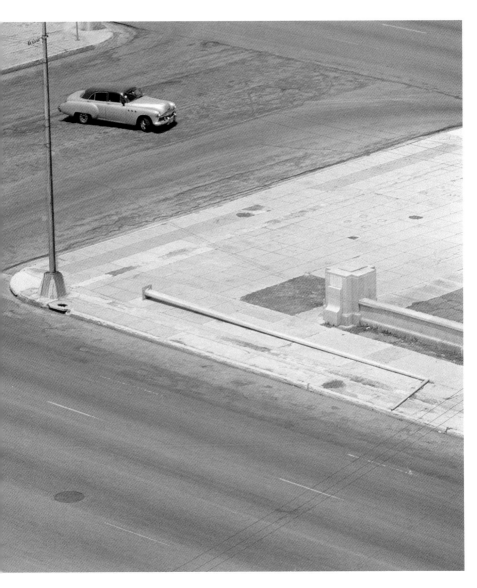

(previous page) **Havana, Cuba, 2003.** This photograph, from Bailey's book *Havana* (2006), is atypical in that it is a study not of the people who make up the place, but of the place itself. The viewer's eye passes across the scene, its movement interrupted only by the lamp post. Our natural inclination to pursue visual order creates a desire to see the top of the pole, but we cannot. The toy-like car is positioned so close to the pole that it unbalances the frame and creates a sense of unease: a feeling that all might not be well beyond our field of vision. Bailey's intuitive sense of composition results in a photograph that, although largely lacking in content, stimulates a powerful intuitive response.

**Helmut Newton, c.2004.** Newton's portrait of Bailey hangs in Bailey's London studio. The older photographer took it six weeks before his death in 2004 and dedicated it, 'To the greatest photographer in the world from your greatest fan and debutante.' Newton's decision to cast himself as an upper-class woman making her appearance in society is itself intriguing, but his tone of admiration is clear. In this portrait Bailey captures a similar sentiment; Newton is positioned in a sparse but elegant composition, softened by his velvet coat and fur stole. Bailey has depicted Newton as the glamorous debutante of his own dedication, lost in a moment of private reverie.

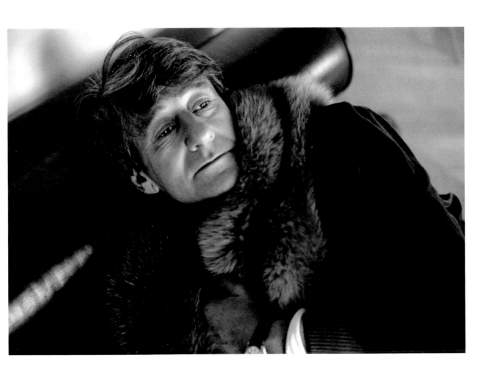

**Damien Hirst, c.2004.** Bailey and Hirst have collaborated on a number of projects, including a photographic series, *The Stations of the Cross* (2004), and a book, *8 Minutes: Hirst & Bailey* (2009). In this photograph Hirst is laid on a plastic tarpaulin with an eviscerated cow. The prop refers to his use of cow carcasses, for example in his first major animal installation, *A Thousand Years* (1990), and his first piece for the Venice Biennale (which also won the Turner Prize), *Mother and Child Divided* (1993). Hirst's naked body exposes him as a human animal and his cadaverous partner acts like the skull in the portrait of *Ralph Fiennes* (page 93): a reminder of mortality.

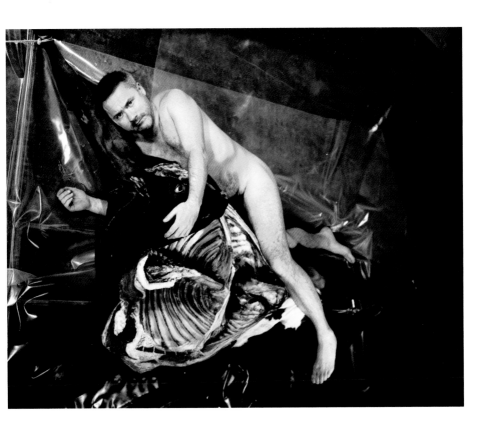

**Michelangelo Antonioni, c.2006.** Bailey took this portrait in the year that the celebrated director began to lose his sight. It is rumoured that the young, cocky photographer in Antonioni's cult film *Blow-Up* (1966) was based on Bailey. Although they had not met before the film was made, Antonioni took notes from the journalist Francis Wyndham, who had recently interviewed Bailey. The film explores the nature of perception: specifically, the dividing line between reality and illusion. In this photograph, Bailey has made this question of 'seeing' part of the composition: Antonioni, with one eye unfocused and the other misted over, seems to see through the piercing green eyes of the cat, an alter ego.

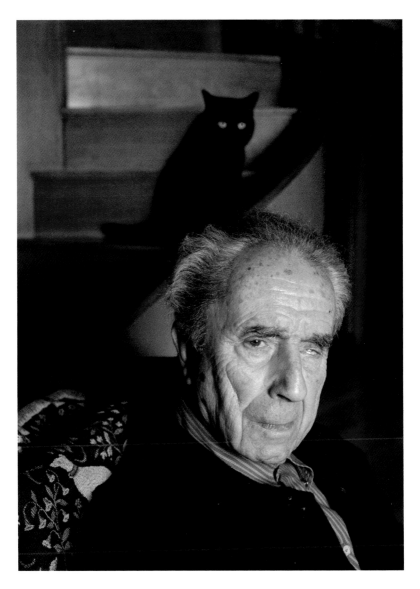

**1938** Born 2 January in Leytonstone, London.

**1941** Moves to East Ham with mother and sister after bombing destroys the family home.

**1957** Buys first camera while stationed in Singapore with the Royal Air Force.

**1958** Returns to London and becomes second assistant to David Ollins, photographer for *Queen* magazine.

**1959** Appointed a photographic assistant at the John French Studio, London. Begins working as a freelance photographer for *Vogue*.

**1960** Marries Rosemary Bramble.

**1965** Publishes *David Bailey's Box of Pin-Ups*. Marries actress Catherine Deneuve.

**1968–1971** Directs and produces television documentaries, including Beaton, Warhol and Visconti.

**1969** Publishes *Goodbye Baby & Amen: A Saraband for the Sixties*.

**1971** Work exhibited alongside that of Gerald Scarfe and David Hockney in 'Snap!' at the National Portrait Gallery, London.

**1974** Publishes *Warhol* and *Beady Minces*.

**1975** Appointed a Fellow of the Society of Industrial Artists and Designers. Marries Marie Helvin. Publishes *Another Image: Papua New Guinea*.

**1976** Publishes *Mixed Moments*, dedicated to third wife Marie Helvin. Launches *Ritz* magazine with David Litchfield.

**1979** Awarded an Honorary Fellowship of the Royal Photographic Society.

**1980** Publishes *David Bailey's Trouble and Strife*.

**1982** Publishes *London NW1*.

**1983** Retrospective held at the Victoria and Albert Museum, London. Publishes *Black and White Memories: Photographs, 1948–1969*.

**1984** Publishes *Nudes 1981–1984*. Exhibition 'David Bailey: The Sixties', held at the International Center of Photography, New York.

**1985** Publishes *Imagine: A Book for Band Aid*. Exhibition 'Band Aid: David Bailey's Photographs from the Sudan' held at the ICA, London. Curates 'Shots of Style' at the Victoria and Albert Museum. Birth of daughter, Paloma Bailey.

**1986** Marries model Catherine Dyer.

**1987** Wins The Golden Lion at Venice Film Festival for his 'Greenpeace Meltdown' commercial. Birth of son, Fenton Bailey.

**1989** 'Bailey Now!' exhibition held at the Royal Photographic Society, Bath.

**1992** Publishes *If We Shadows*.

**1995** Publishes *The Lady is a Tramp: Portraits of Catherine Bailey* and releases his short film of the same name. Birth of son, Sascha Bailey.

**1997** Publishes *David Bailey's Rock and Roll Heroes*.

**1998** Publishes *Models Close Up*, to coincide with the release of a documentary commissioned by Channel 4.

**1999** Solo exhibition 'Birth of the Cool 1957–1969 & Contemporary Work' tours to Barbican Art Gallery, London. Publishes *Archive One, 1957–1969*. Directs feature film *The Intruder*.

**2000** Exhibits at Moderna Museet, Stockholm.

**2001** Awarded CBE. Publishes *Chasing Rainbows*.

**2003** Publishes *Locations: The 1970s Archive*.

**2004** Exhibitions 'David Bailey & Damien Hirst: The Stations of the Cross' and 'Artists by David Bailey' held at the Gagosian Gallery, London.

**2005** Publishes *Bailey's Democracy*, to accompany exhibition at Faggionato Fine Art, London.

**2006** Publishes *Havana*, to accompany exhibition at Faggionato Fine Art.

**2007** Publishes *NY JS DB 62* and *Pictures That Mark Can Do*. Exhibition 'Pop Art' at the Gagosian Gallery, London.

**2009** Publishes *8 Minutes: Hirst and Bailey*.

Phaidon Press Limited
Regent's Wharf
All Saints Street
London N1 9PA

Phaidon Press Inc.
180 Varick Street
New York NY 10014

www.phaidon.com

First published 2010
©2010 Phaidon Press Limited

ISBN 978 0 7148 5783 1

Designed by Julia Hasting
Jacket design by Hans Stofregen
Printed in China